Ilya and Emilia Kabakov

The
House
of
Dreams

Serpentine Gallery, London

Ilya and Emilia Kabakov
The House of Dreams 2005
Installation at the Serpentine Gallery, London

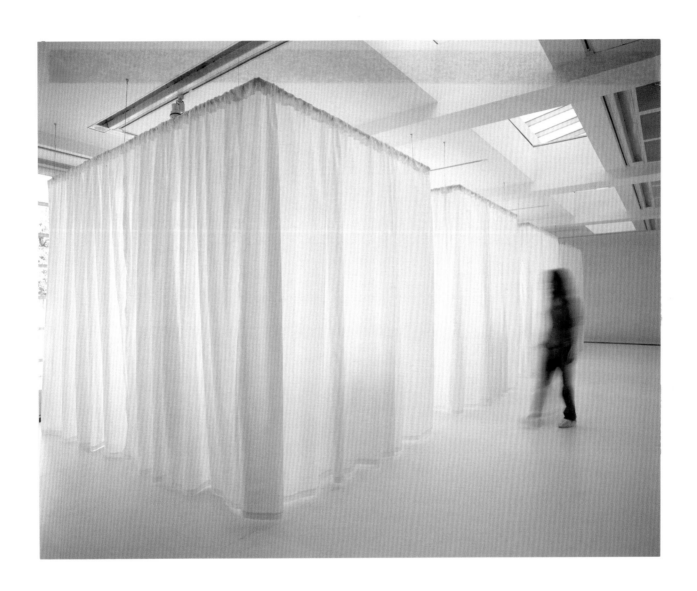

Contents

Sponsor's Statement

Bloomberg is pleased to offer its continued support to the Serpentine Gallery through sponsorship of *Ilya and Emilia Kabakov: The House of Dreams*, a unique installation created for the Serpentine. Both playful and meditative, the installation, like much of the Kabakovs' work, is all-encompassing, allowing visitors to escape as much as to reflect. *The House of Dreams* not only invites contemplation but also provokes imagination.

As a leading global financial information services company, Bloomberg is deeply committed to education and creativity, and to expanding access to art, science and the humanities. Through support of educational and cultural institutions worldwide, Bloomberg fosters a broad range of creative initiatives – from exhibitions and audio tour programmes to student fellowships and public art installations – that promote public awareness and appreciation of the arts and encourage higher education.

Sponsorship of the Kabakovs' exhibition reflects Bloomberg's sustained commitment to the arts and builds on Bloomberg's long association with the Serpentine Gallery's exhibition and education programmes.

Bloomberg

Director's Foreword

Since moving to the West from the Soviet Union in 1987, Ilya Kabakov has become known for pioneering the concept of the 'total installation', a term he coined to describe the complex environments he creates by combining objects, paintings, drawings, text and sound that have been presented in museums and galleries worldwide. Since the late 1980s he has collaborated on large-scale projects with Emilia Kabakov, whom he married in 1992, and together they have produced ambitious installations that explore history, literature, art and philosophy. These room-scale works place great importance on storytelling and many of their projects have revolved around the creation of fictional characters and scenarios.

For their exhibition at the Serpentine, the Kabakovs have designed *The House of Dreams*, a new piece that continues their fascination with narrative and fantasy. They have completely transformed the galleries to create a tranquil, all-white environment in which visitors may rest and daydream in quiet contemplation. For the artists, the project is a response to their observation that a chronic lack of sleep and rest plagues many individuals in modern society, and this installation explores themes of healing and recuperation.

The Serpentine is delighted to present this major new commission by Ilya and Emilia Kabakov and we are particularly indebted to them as well as to the many individuals and organisations that have been so crucial to the realisation of this exhibition. Above all, it is a great privilege that the Kabakovs accepted our invitation to show their work at the Gallery and we would like to thank them for the time and consideration they have given to every aspect of this project. We are also grateful to the artists for conceiving and overseeing the production of a special Limited Edition print and allowing the Gallery to benefit from its sale.

Our heartfelt thanks go, once again, to Bloomberg for its sponsorship of *Ilya and Emilia Kabakov: The House of Dreams*, as well as for its continued and invaluable support of the Gallery's exhibition and education programme that is so important for its ongoing development. We are particularly indebted to Lex Fenwick and Sayu Bhojwani for their commitment to making our collaboration such a success. We are also grateful to Renaissance Capital's Managing Director, Alastair Cookson, who immediately understood the importance of this exhibition and championed it within the company and, in particular, to Stephen Jennings, Chief Executive, who matched his enthusiasm to the project. Their generous contribution to the exhibition is a new relationship for the Gallery and resulted from an introduction by our valued associates Yana Peel and Candida Gertler. Our special thanks are extended to The Henry Moore Foundation, in particular to Timothy Llewellyn, Director, who together with the Trustees of the Foundation have supported this publication, which is a lasting testament to Ilya and Emilia Kabakov's commission at the Serpentine. We especially wish to thank the Council of the Serpentine for their ongoing commitment to the Gallery. In addition, thanks are due to Hayman Barwell Jones Wines for their kind donation of Firebird Legend wine as well as to Heineken for their contribution to the exhibition's opening celebrations.

We are grateful to the artists' representatives who assisted the Serpentine in realising this ambitious project. Niccolo Sprovieri of Pescali & Sprovieri Gallery, London, has been a long-term admirer of the Kabakovs' art since his first presentation of their work in Rome in 1992; while Michael Hue-Williams at Albion in London has worked with the artists on important projects that span continents and he continues to make a significant contribution to our cause. We are also indebted to Sean Kelly, a long-standing friend of the Serpentine, as well as Amy Gotzler at Sean Kelly Gallery in New York for their advice from the outset and throughout the development of *The House of Dreams*.

Herman Lelie, working with Stefania Bonelli, has designed this handsome publication featuring insightful essays by Dr Jonathan Fineberg, Gutsgell Professor of Art History at the University of Illinois, and Dr Rod Mengham of Jesus College, University of Cambridge. The publication benefited from Melissa Larner's editorial acumen as well as the expertise of Richard Davey and his colleagues at FS Moore. We are also grateful to Mark Jenkins of K2 Screen as well as Bob Pain and Lorraine Sandy of Omnicolour for producing the artists' Limited Edition print. Sam Forster and his team have been instrumental in the realisation of this project and their involvement is much valued.

Finally, without the enthusiasm and dedication of the entire Serpentine team, this exhibition could not have been realised. I thank, as ever, everyone at the Gallery, in particular Rochelle Steiner, Chief Curator and curator of this exhibition; Mike Gaughan, Gallery Manager; and Kathryn Rattee, Exhibition Organiser, for their work with the artists throughout every stage of this project.

Julia Peyton-Jones
Director

SOUTH GALLERY

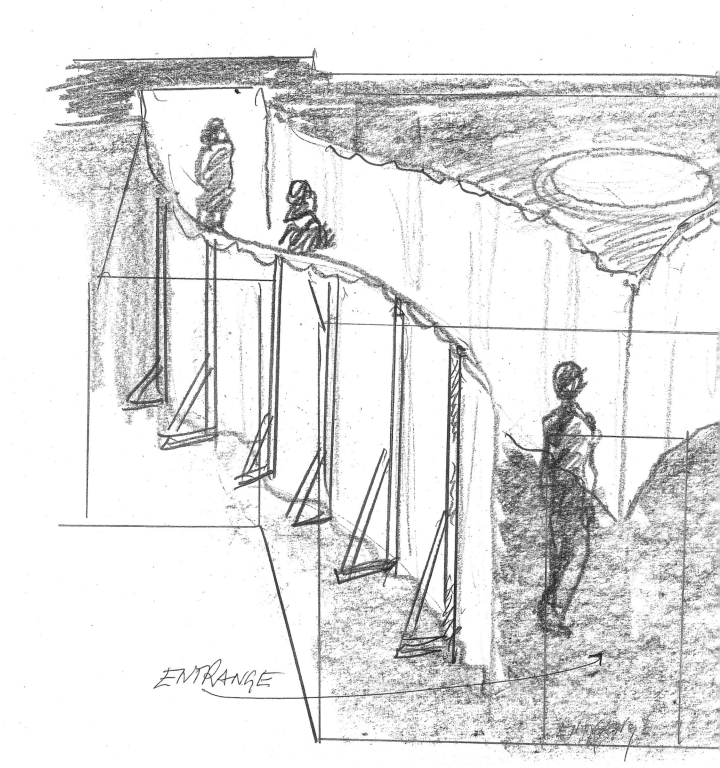

ENTRANCE

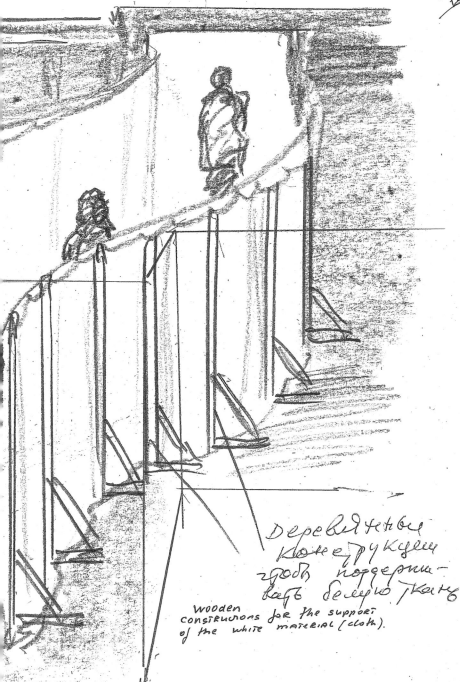

ENTRANCE IN THE EAST GALLERY

деревянные
конструкции
чтобы поддержи-
вать белую ткань

wooden
constructions for the support
of the white material (cloth).

Pages 12–17:
Ilya and Emilia Kabakov
The House of Dreams 2005
Drawings for installation at the Serpentine Gallery, London

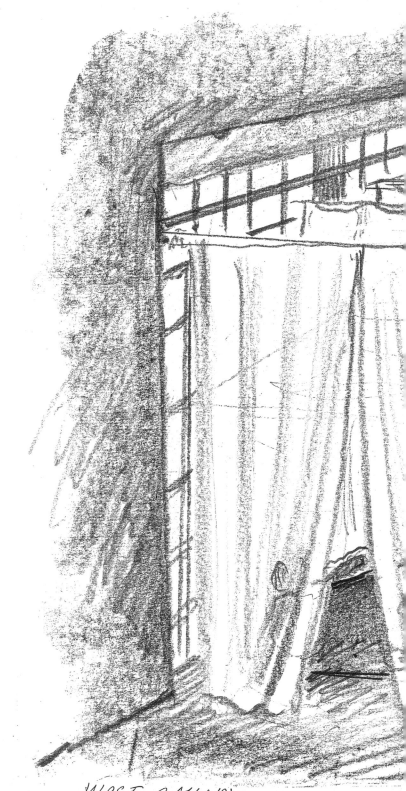

WEST GALLERY

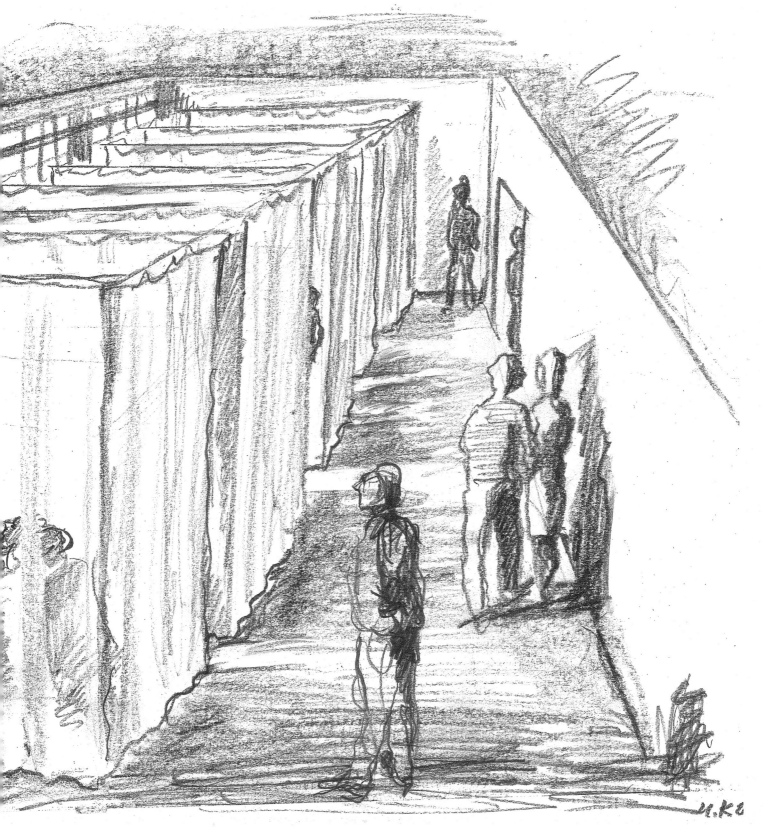

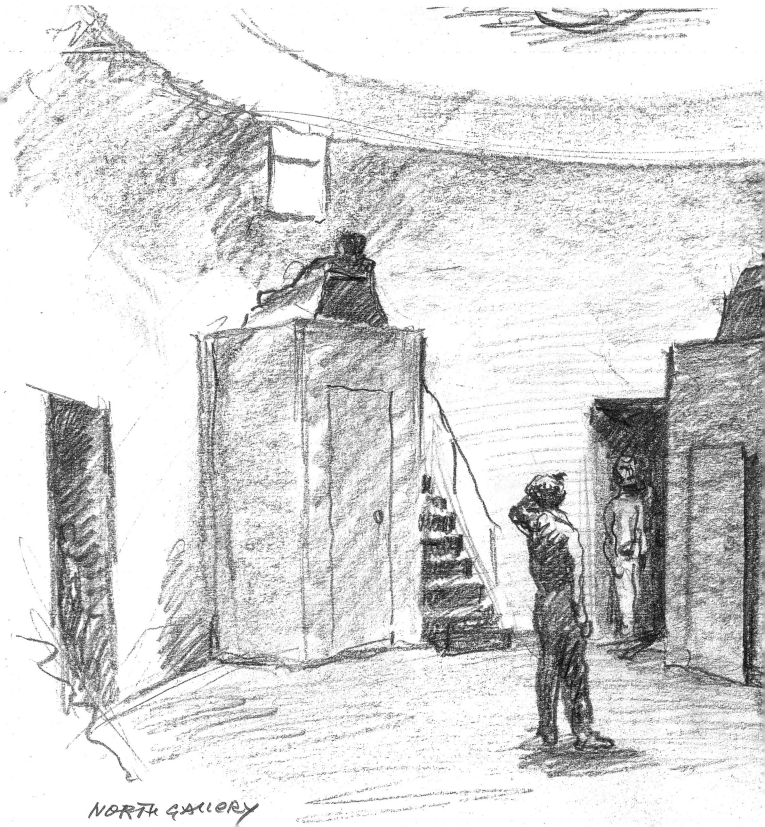

NORTH GALLERY

Agents and Patients

Rod Mengham

In his early text *White Nights*, 1848, the great nineteenth-century novelist Fyodor Dostoyevsky offers a diagnosis of the Russian dreamer. His narrator is a character whose imaginary interactions with other people have long since compensated for a social reality of total isolation:

> The dreamer — if a precise definition is required — is not a person, but a sort of genderless creature. He usually prefers to settle in some inaccessible spot, as if to hide from the very daylight, and once he has taken up residence, he grows attached to it like a snail, or at least like that amusing creature which is both animal and house, and is called a tortoise. [...] He desires nothing, because he is above desire, he has everything because he has surfeited, because he is the artist of his own life and creates it for himself by the hour as the mood takes him.[1]

The over-productiveness of fantasy in confinement, the underlying desire for withdrawal and secretion, are symptoms of a Dostoyevskian malaise, but they are equally rife among the numerous fictional characters devised by Ilya and Emilia Kabakov. A particularly striking parallel can be drawn between the nineteenth-century recluse and the protagonist of their *In the Closet*, 1997, initially devised for inclusion in the Kabakovs' installation of hypothetical ideas, *The Palace of Projects*, 1998. The dweller in the closet equips himself with shelves, utensils, books, lighting, and even a bed, despite the tortoiseshell scale of his bizarre habitat. The Kabakovs' analysis of the dreamer's motivation assumes a failure of nerve very similar to that of his literary antecedent:

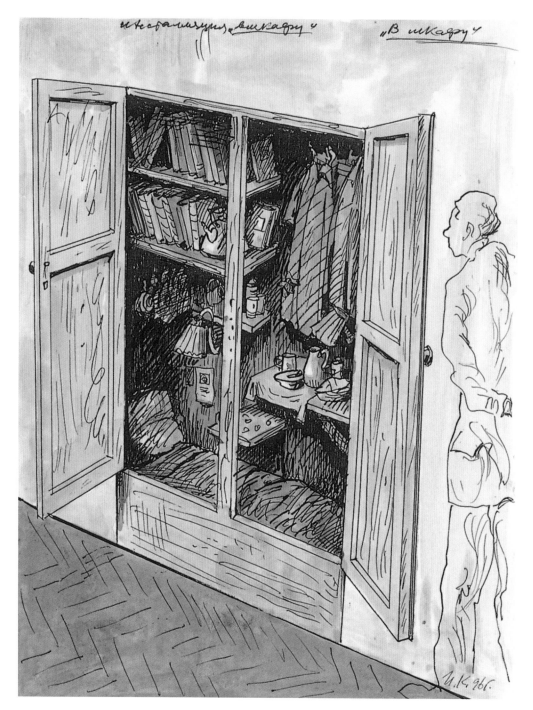

Ilya Kabakov
Drawing for *In the Closet* 1996
Watercolour, felt pen and
coloured pencil on
photocopied drawing
27.8 x 21.6 cm

the person who has settled into the closet has hidden
precisely from such curious people as the viewer, he has
fled from that life in which all of us are submerged from
morning until night, he wants to disappear, to hide from the
hustle and bustle and noise of the corridor which we are
walking along. He would like to attain solitude or peace –
but his peace and solitude are doomed, since anyone can
peer into his life. [2]

What the artists make explicit through the physical experience of this work
is the discomfort, the embarrassment, of the viewer or reader that is only
implicit in Dostoyevsky's text. Much of private life was lived in public
during the Soviet era, and many of the Kabakovs' installations test the
viewer's assumptions about where the threshold of confidentiality lies.
Walking into one of their spaces can feel like intrusion; inspection can feel
like interference. The anxiety with which the threshold between private and
public is negotiated is focused on the narrator in Dostoyevsky's text,
whereas in the installation In the Closet it is at the centre of our encounter
with the work, when we hesitate over whether or not to open the door,
whether we peer inside or just glance and walk away.

Artist and curator Joseph Bakshtein formulates the claim that
Kabakov's miniaturisation of domestic space in several of his works
provides 'the central metaphor of life in the Soviet Union'.[3] But the parallel
between Dostoyevskian and Kabakovian points of view suggests otherwise.
The dreamer's fundamental division of purpose – wanting to eavesdrop
on other people's lives but not take part in those lives, needing to feel he
is at the hub of everyday affairs while remaining invisible to passersby –
seems to qualify as a constant factor in Russian culture of the last two
centuries. Both Dostoyevsky's and the Kabakovs' dreamers inhabit a
cultural formation that began to take shape after the failed insurrection
of December 1825, when a group of Russian officers tried to overthrow

Tsar Nicholas I. This was a crucial turning-point in Russian history that encouraged the authorities in their cultivation of a secret state, enhancing the repressive powers of the police and driving intellectual dissent into hiding. The Soviet Union did not invent the conditions in which artistic culture was forced underground, it merely accentuated and refined them, and in the process lent a special poignancy to the forging of a utopian politics, to the social anthropology of dreams.

The now immense oeuvre of Ilya and Emilia Kabakov revolves around the paradox of a culture whose degradation, both moral and material, often seemed to relate inversely to the grandiose ambitions of its five-year plans and other impossible projects. Early Soviet art was often naively complicit with this disproportion: *Fulfil the Five Year Plan in Four Years*, 1933, is the title of one work by the Constructivist artist Varvara Stepanova, in the collection of the Museum of Modern Art, New York. The Kabakovs' extraordinary labour of commemoration and interpretation is fuelled by the strange candour of those archaic desires, and by their subsequent alienation; by the energising fallacies not just of individual sensibilities, but of an entire political eco-system. They tap into a reservoir of dreams that were the myths of at least three generations.

Dreaming is literally and conceptually at the centre of the Kabakovs' design for their new installation at the Serpentine. Beneath the dome-like architecture of its central gallery, a radial plan features four divans inclined on pedestals that encourage the viewer to imagine a ritualised form of sleep. The circular structure brings to mind an observatory, while the elevated beds also resemble sarcophagi. On a lower level are beds that recall hospital cots, on whose curtains a magic lantern show is projected. Thus above and facing outwards from the centre of the room a form of universal sleep is presented, with evocations of the dreams of the dead. Below and facing inwards, meanwhile, are the manifestations of delusion, medicalised, narcotised and perhaps pathological.

What is remarkable about the design of this new project is its close similarity to the Kabakovs' earlier conception, *NOMA or The Moscow Conceptual Circle*, 1993, which featured hospital beds and other furniture in 12 rooms. The radial plan of NOMA divides up the circular structure into a series of spaces or 'slices' open to the centre, with passageways through doors between them. Each of these 12 spaces is dedicated to one of the participants of *NOMA*.[4] *NOMA*, at first, seems antithetical to the desire for repose and sublimation in *The House of Dreams*, but it too tries to adjudicate between the dreams of the individual and the confor-mations of a group identity. In a certain sense, this earlier construction is a foundational work, since it attempts to give spatial expression to the ensemble of artistic and intellectual collaborations developed over a number of years by the group of Conceptual artists to which Ilya belonged in Moscow. It anticipates the circular arrangements beneath a dome that govern the layout of *The House of Dreams* and gives plasticity to the idea of the 'chronotope', developed by the early twentieth-century philosopher and literary theorist Mikhail Bakhtin in relation to the novel.[5] It also attributes to this design a religious aura that seems more naturally intrinsic to the later work: the viewer is supposed to receive the impression of 'some sort of secret, ritualistic place, a departure site of some sort of cult.'[6]

There is more conceptual agitation in the earlier work, which substitutes the buzz of language for the silence of repose; instead of a company of sleepers and dreamers invited to take their ease, it installs a team of 'chatterers' in the form of textual displays relating to each of the thirteen artists nominated as participants in the circle. Despite this contrast, both projects conceive of their *dramatis personae* as patients of a kind: in the earlier, more volatile work, the participants figure as 'highly flammable … material (in our case, a certain quantity of neurotics with … the ability to articulate their own neuroses)'.[7] The Kabakovs clearly regard the interaction of the different members of the group of characters as the key to their being 'cured'. The establishment of a dynamic network of

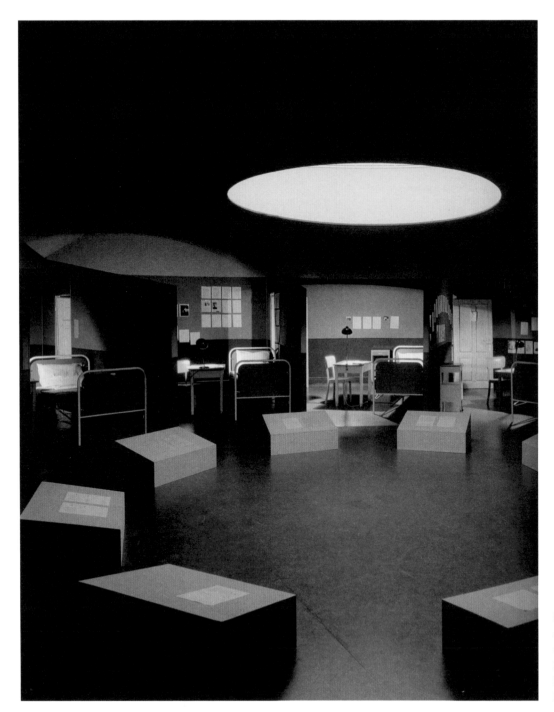

Ilya Kabakov
*NOMA or The Moscow
Conceptual Circle* 1993
Installation at Hamburger
Kunsthalle, Hamburg, Germany
Photo © 2005 Elke Walford

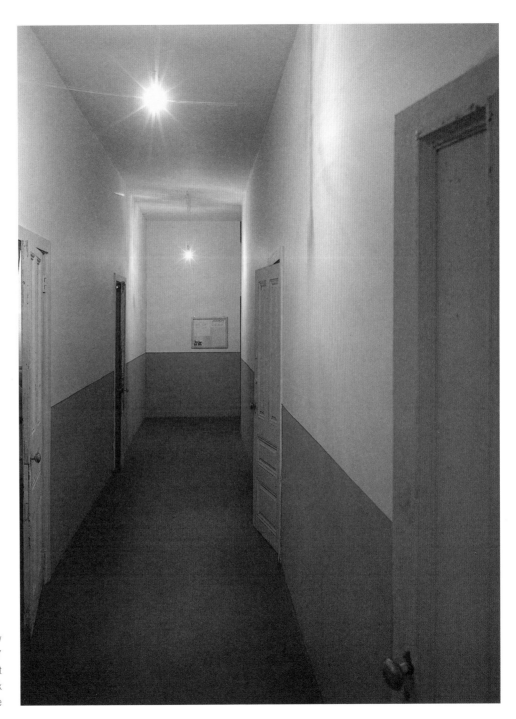

Ilya Kabakov
Treatment with Memories 1997
Installation for *1997 Whitney Biennial* at
Whitney Museum of American Art, New York
Photo © 2005 D James Dee

communication prevents knowledge from becoming coagulated, whether as individual *idées fixe* or as collective ideology. 'Incessant chatter' must be held in tension with 'incessant introversion'. The installation features a range of texts that provide descriptions not only of 'external' but of 'internal' circumstances; of both communal and subjective realities.

Interestingly, Kabakov quite deliberately uses Bakhtinian terminology in mapping the lines of force that converge and diverge in the transactions of the group. He describes each room, or booth, as an 'entirely closed world of subjectivism'. The risk of this introspection is 'monologism': 'the individual monologic speech act in this scheme is to a great degree doomed to reflect a fiction engendered by "large" collective formations'; whereas, a 'small local circle built on the basis of the individuation of its participants [is] capable of undermining and repudiating the integrity of communal speech ... through a system of dialogic' interventions.[8] The politics of the nucleated group, the activity of the avant garde, is judged to be the most effective subversion of the monomania of the individual dreamer on the one hand, and of the monolithic ideology of the state on the other.

Revealingly, Kabakov names the Decembrists as precursors to the Moscow Conceptualists in his description of *NOMA*, evoking the legacy of 1825 as a pretext for actively contesting the circulation of stereotypes.[9] A number of other installations that hinge on their allusion to official definitions of mental health, in a culture where psychiatry was employed as an agent of social discipline, present the 'patients' as absent, frequently projected, imaginary receptors for different kinds of treatment. Hospital beds abound in the Kabakovian output; most conspicuously in *Treatment with Memories*, 1997, where the 'treatment procedure' bears comparison with that of *The House of Dreams*. *Treatment of Memories* is modelled after a long corridor in a provincial Russian hospital, with six doors, leading to individual procedure rooms. The treatment involves the display of slides containing biographical material; each slide-show divulges an individual

history, its details unrepeatable. However, the soothing rhythm of the 11-second intervals between slide changes would tend to narcotise the mood of the hypothetical 'patient' as well as the 'relatives' who might visit. Their joint reception of visual information is both assimilated and disturbed by the point of view of the visitor to the installation, who becomes progressively absorbed in the individual narratives. As with many of these thematically grouped installations, a very fine line is drawn between evidence of communication and of self-communing. There are further vivid parallels between *The House of Dreams* and *The Children's Hospital*, 1998, where a similar slide-show element is supplied by a series of customised miniature music theatres, each angled so as to be visible and audible equally to 'patient' and visitor.

But perhaps the most resonant correlation for *The House of Dreams* is with the recent *A Universal System for Depicting Everything*, shown at the Göppingen Kunsthalle in Germany in 2002.[10] There, the place of the magic lantern show is taken by the separated pages of the artists' *Albums* displayed on the four walls of a large hall, in the centre of which sit two objects: a glass pyramid and a hospital bed. These objects and their forms recall many similar constructions in the history of the Kabakovs' oeuvre. The pyramid evokes the towers, monuments and architectural blueprints of the early Soviet era, and especially the Tower of Babel-like structure of *The Palace of Projects* seen in London at the Roundhouse in 1998. That great upward spiral, like the dome in *The House of Dreams*, epitomises the ultimate ambition of sharing in the universal, perhaps in the comprehensive scope of a divine point of view, while its failure announces the descent into a history of incomprehension, the loss of a universal language, the language of a dream. The Kabakovs hold its flawed grandeur in a permanent tension with the implications of the hospital bed, suggesting that the obsessive attention to detail in the pursuit of their projects is a form of insanity, nothing more nor less than the paranoid delusions of a mental patient.

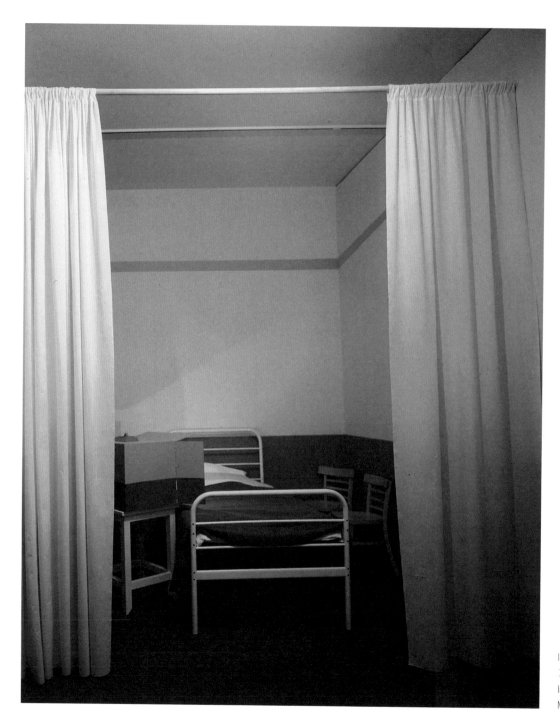

Ilya and Emilia Kabakov
The Children's Hospital 1998
Installation at Irish Museum of
Modern Art, Dublin

The *Albums* in *A Universal System for Depicting Everything* comprise an attempt to represent, in two dimensions, the idea of a system for depicting objects in four-dimensional space. Theoretically, this would involve representing spatial relations from all sides at once, and temporal relations from all points in time simultaneously.[11] In practical terms, what the viewer gets is a series of beguiling images subjected to the systematic distortions of elongation and compression, of amplification and shrinkage, resembling the condensations and displacements of the dream-work. The images are decipherable, just. They are unmistakably drawn from the same image-bank as the Kabakovs' other evocations of a relatively early period in Soviet history, mixing innocence and idealism with the first inklings of a future that should never have happened.

In the Kabakovs' commentary about *Album IX*, the most comprehensible form taken by the fourth dimension is evident in the deformations of real space that are occasioned by our desires. In this respect, perhaps the entirety of the Kabakovs' oeuvre should be thought of as four-dimensional, given the intensity of its focus on the living spaces of Soviet culture, spaces that are obsessively re-imagined, reworked, reconfigured.

The irony embodied in *A Universal System for Depicting Everything* is that its constant demand for the abandonment of a unified point of view, of monologism – its insistence on the dialogic migration of points of view and objects, both in time and space – is precisely what is achieved in the experience of installation art. The Kabakovs' installations represent a departure from the genre's main lineage in their very public assault on private space. At the centre of their work is an unremitting examination and critique of actual living conditions, in a culture in which the very concept of 'home' may be standardised, deprivatised, rendered anonymous. Their installations are the logical outcome of a social and political history in which the citizen as viewer is turned into patient rather than agent, and is overpowered by a lack of choice, by a perspective that leaves hidden or invisible the real space of desire, a space that can only be visited in dreams.

1

Fyodor Dostoevsky, *A Gentle Creature and Other Stories*, trans. Alan Myers (Oxford: World's Classics, 1995), pp 17, 22–3

2

Ilya Kabakov, *Installations 1983–2000: Catalogue Raisonné* (Dusseldorf: Richter Verlag, 2003), Vol 2, p 237

3

Ibid., p 239

4

Kabakov counts himself as the thirteenth participant.

5

'In the literary artistic chronotope, spatial and temporal indicators are fused into one carefully thought-out, concrete whole. Time, as it were, thickens, takes on flesh, becomes artistically visible; likewise, space becomes charged and responsive to the movements of time, plot and history. This intersection of axes and fusion of indicators characterizes the artistic chronotope.' Mikhail Bakhtin, 'Forms of time and of the chronotope in the novel', in *The Dialogic Imagination*, trans. Caryl Emerson and Michael Holquist (Austin: University of Texas, 1981), p 84

6

Kabakov, *op. cit.*, Vol. 1, p 487

7

Ibid.

8

Ibid., p 489

9

Ibid., p 487

10

Ilya Kabakov, *A Universal System for Depicting Everything* (Dusseldorf: Richter Verlag, 2002)

11

Compare Bakhtin: 'What counts for us is that [the chronotope] expresses the inseparability of space and time (time as the fourth dimension of space).' *The Dialogic Imagination, op. cit.*, p 84

Pages 32–41:
Ilya and Emilia Kabakov
The House of Dreams 2005
Installation at the Serpentine Gallery, London

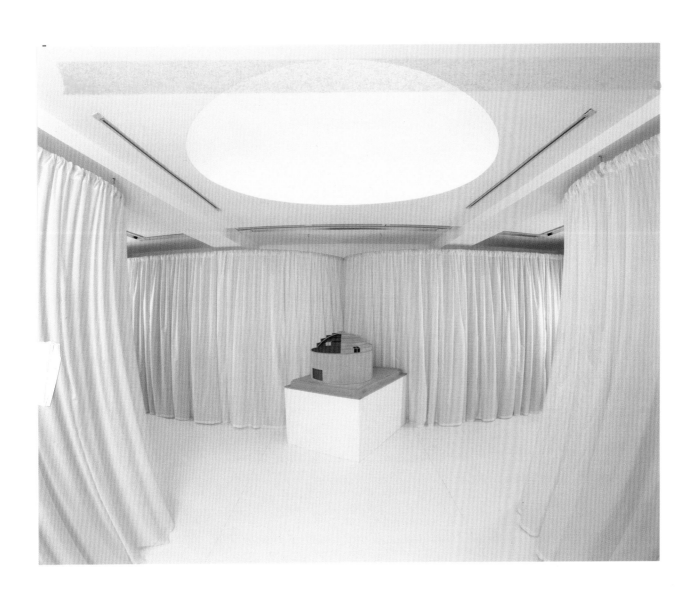

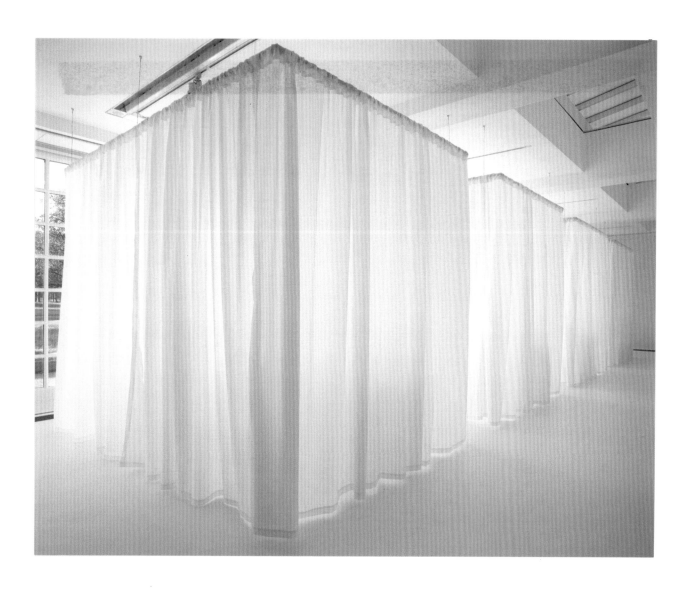

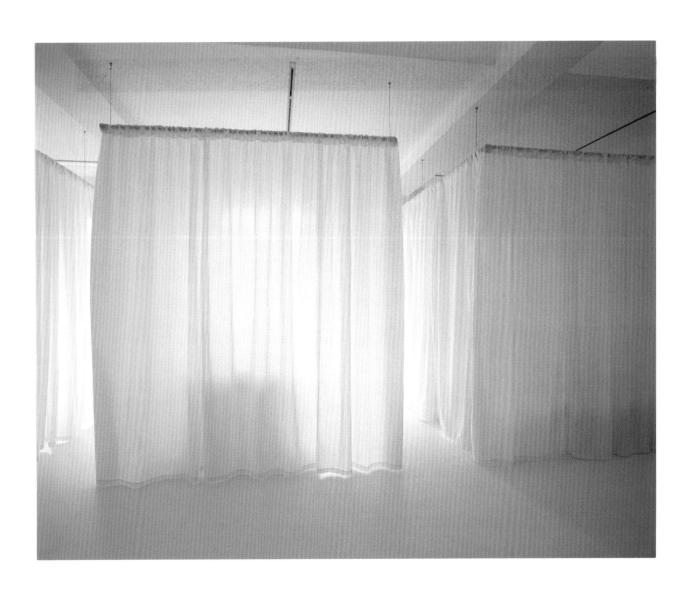

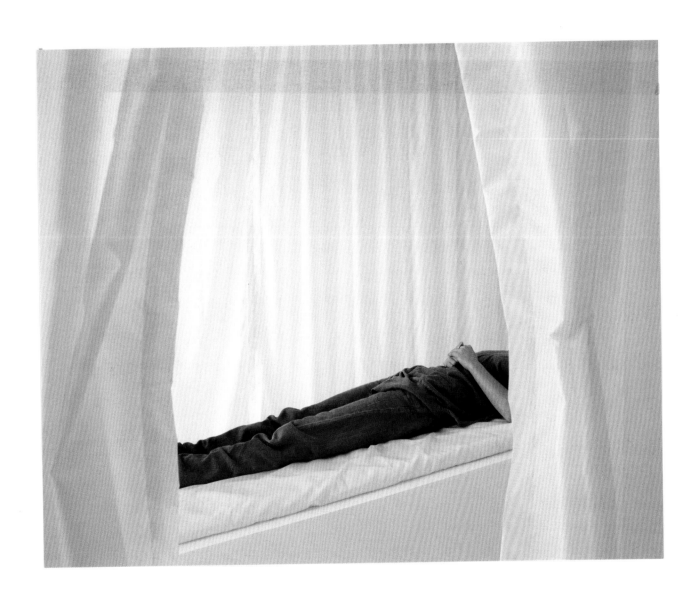

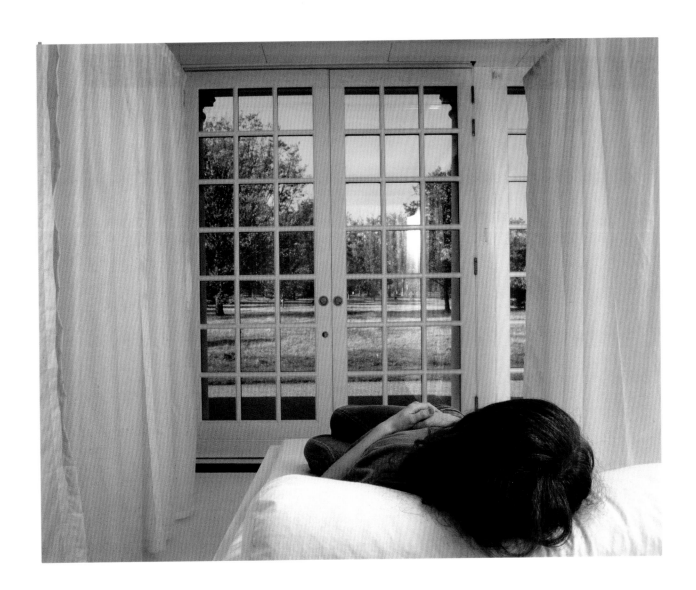

To Sleep, Perchance to Dream:
The House of Dreams

Jonathan Fineberg

Ilya and Emilia Kabakov are the pre-eminent figures of narrative installation art today.[1] As with Wassily Kandinsky's history in pioneering abstraction in the early 20th century, others had worked in the form earlier, but Kandinsky and the Kabakovs were the ones who theorised their respective genres and created an extensive body of the most compelling and lasting works in the medium. The Kabakovs have also come to stand for a unique style of non-teleological narrative art that has no beginning or end and leads nowhere in particular. Instead, their narratives form a collection – of events, of tiny objects, of details – and, in turn, each constitutes a unit of data in a meta-collection of narratives. In this too, there is a curious parallel with Kandinsky, whose abstractions of 1909 – 11 did not eliminate objects, but rather decontextualised them so as to exploit their rich associations without subordinating them to the narrow limits of a story line.

Part of what makes the Kabakovs' installations so important is how presciently their non-hierarchical accumulations of vast quantities of images, texts and fragmentary objects gave formal expression to the emergence of the information-dominated world of the 21st century. 'If in physics the world is made of atoms and in genetics it is made of genes, computer programming encapsulates the world according to its own logic', writes new media theorist Lev Manovich in his essay 'Database as Symbolic Form'. He goes on to describe this logic as reducing everything into two categories that complement one another: data and algorithms. 'Any process or task is reduced to an algorithm', he explains, 'a final sequence of simple operations which a computer can execute to accomplish a given task'. Any fact or object in the world, 'be it the population of a city, or

the weather over the course of a century, a chair, a human brain' is data, available for any sorting algorithm to search and retrieve.[2]

The Kabakovs' work is the ultimate database of prosaic existence, the archive of daily life, and their narrative characters are the sorting filters that bring different skeins of coherence to the data. (Even chaos has a conceptual coherence.) As Ilya says, it is 'a seemingly commonly known and even trivial truth: the world consists of a multitude of projects, realized ones, half-realized ones, and not realized at all. Everything that we see around us, in the world surrounding us, everything that we discover in the past, that which possibly could comprise the future – all of this is a limitless world of projects.'[3]

The Palace of Projects, 1998, is an imaginary spiral building containing 65 utopian projects, proposed by hypothetical authors, which was presented in the form of an installation at the Roundhouse in London. In the introduction to the book that accompanied it, the Kabakovs offer a metaphor for the dilemma of unlimited information that has come to characterise our times: 'Studying a boundless area of utopias and projects', Ilya writes, 'at first you begin to drown in the gigantic sea not only of all kinds of proposals and beginnings, but also in the abundance of the goals and ideas which guided their inventors and authors'. But, he continues, 'gradually, it is possible to discern a few groups of … intentions.'[4]

The Kabakovs use narrative not only to sort all this detail, but also to bring their viewer into a kind of intimacy with it. Ilya began the text that frames his seminal work, *The Man Who Never Threw Anything Away (The Garbage Man)*[5] from *Ten Characters*, 1985–88, in this way:

> … He never threw anything away.
> … He sat in his corner (he lived all his life in a small room located in the very farthest corner of a large communal apartment). He almost never went out anywhere …
> What he did in his little room remained unknown.[6]

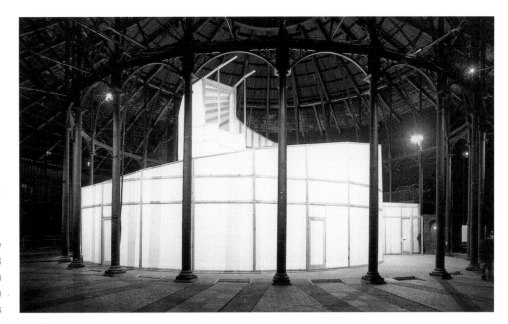

Ilya and Emilia Kabakov
The Palace of Projects (exterior view) 1998
Installation at the Roundhouse, London
Organised by Artangel, London
Photo © 2005 Dirk Pauwels

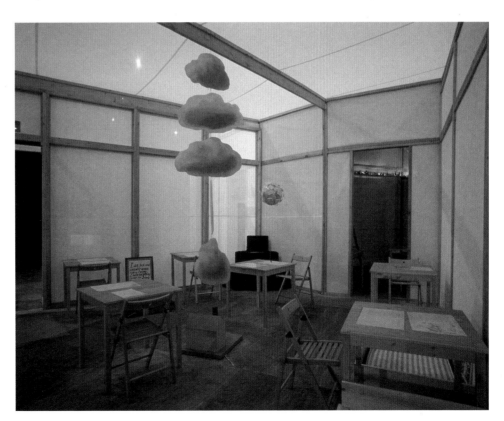

Ilya and Emilia Kabakov
The Palace of Projects (interior view) 1998
Installation at the Roundhouse, London
Organised by Artangel, London
Photo © 2005 Dirk Pauwels

Ilya goes on to weave a story that speculates on the mystery of the things, large and small, littering the stairwells and halls of the crowded communal apartment, 'incidental things, which were left, discarded and forgotten by no one knows whom'. The installation is crammed into a narrow space with countless items – some as trivial as a collection of small pieces of string. 'The entire room, from floor to ceiling was filled with heaps of different types of garbage',[7] all carefully inventoried with little paper tags. It is a world in which no item is so small as to be overlooked, an archive of everything. This work transfigures the most accidental details of daily life into condensations of memory and association.

Among the debris in *The Man Who Never Threw Anything Away*, a text describes a tenant who finds a manuscript entitled 'Garbage' that states: 'In our memory everything becomes equally valuable and significant. All points of our recollections are tied to one another. They form chains and connections in our memory which ultimately comprise the story of our life. To deprive ourselves of all this means to part with who we were in the past, and in a certain sense, it means to cease to exist.'[8] So even one's existential self is constituted of an archive.

The most poignant example of this is Kabakov's 1993 installation *The Boat of My Life*, where he attaches a line of text from his autobiography, printed on a slip of paper, to bent paper clips, dog-eared snapshots or torn scraps of cloth. These are glued in a grid to cardboard sheets that lie on top of old clothes piled in packing boxes on the deck of a large, open boat installed in the gallery. The imaginative trails of association evoked by these prosaic artefacts cast light on life's ironies, its moments of tragic self-confinement and pathos, but also on its spirituality and the exhilarating liberation we find in the act of imagination itself. The Kabakovs' idea of 'total installation' is founded on this epiphany in a teacup.[9]

In some installations, like *The Man Who Flew into Space from His Apartment*, 1985 (another from *Ten Characters*), the narrative seems at first to move along a story line:

The lonely inhabitant of the room as becomes clear from the story his neighbor tells, was obsessed by a dream of a lonely flight into space … A catapult, hung from the corners of the room, would give this new 'astronaut' who was sealed in a plastic sack, his initial velocity and further up at a height of 40–50 meters, he would land in a stream of energy through which the Earth was passing at that moment as it moved along its orbit. The astronaut had to pass through the ceiling and attic of the house with his vault. With this in mind, he installed powder charges and at the moment of his take-off from the catapult, the ceiling and roof would be wiped out by an explosion, and he would be carried away into the wide-open space. Everything was in place late at night, when all the other inhabitants of the communal apartment are sound asleep. One can imagine their horror, fright, and bewilderment. The local police are summoned, an investigation begins, and the tenants search everywhere – in the yard, on the street – but he is nowhere to be found. In all probability, the project, the general nature of which was known by the neighbor who told the investigator about it, was successfully realized.'[10]

But these narrative vignettes are themselves more like units floating in a vast collection of discrete stories and items that co-exist in the Kabakovs' philosophical archive, without hierarchy, waiting to be retrieved and combined in any number of possible ways. The physical installation of *The Man Who Flew into Space from His Apartment* is a single room within the larger apartment, in which one room is devoted to each character. It is wallpapered with a plethora of images – drawings, posters, photographs, an archive within an archive. And in the recombination of these rooms into one of many possible complex wholes, as he wrote in his autobiography, 'for the first

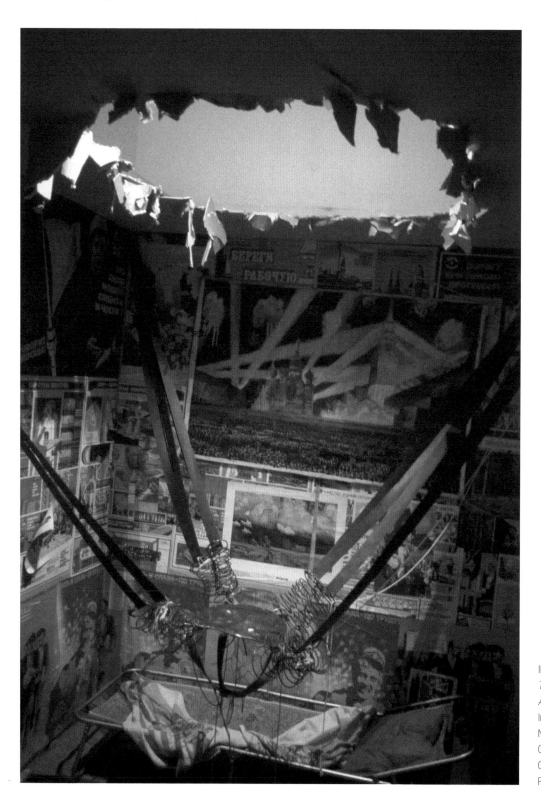

Ilya Kabakov
The Man Who Flew into Space from His Apartment 1985
Installation at Ronald Feldman Fine Arts, New York, 1988
Collection Musée national d'art moderne, Centre Pompidou, Paris
Photo © 2005 D James Dee

time I had brought the atmosphere of our world to another world … [I]t's the first (successful) experiment with the "total" installation', he added.[11]

Even a small change in context (for example, a different space for ordering the same contents) can transform meaning. In the explanation of project three in *The Palace of Projects* he writes:

> Our entire private life, if there is such a possibility, occurs in our apartment or our room. Even if our thoughts and fantasies are sometimes elevated (whenever possible) and we try to overcome depressing everyday existence, all that surrounds us in this existence doesn't permit us to do so. And here, a significant portion of the blame lies in the situation in our apartment or room where we spend the greater part of the day. We are not talking about the people, the family with whom you live, but about those things that you bump into without noticing it – the couch, tables, closets – but primarily, the very box of the room, where all of this is located, the constant 'atmosphere' reigning in the space surrounding you … But there is a simple means for breaking away, for escaping from this horizon without changing anything in the arrangement of your room: to escape upwards, to evaporate into a different, new space of being. You only have to do a small thing. In one part of the room – best of all in the center – you should remove the parquet, uncover the beams that hold up the floor, and saw out some of them so that a deep hole downwards opens up. You will see that everything around has suddenly become transformed.[12]

The Kabakovs' *The House of Dreams*, like most of their works, begins with the description of a human circumstance that is common and banal, and at the same time oddly profound and universal. 'Many of us suffer

from insomnia, from shallow sleep, from oppressive, agonizing dreams that are hard to shake during the course of the day', Ilya writes in his brief description of the concept for the Serpentine installation. Is it Kabakov himself who is sleeping badly? And who is Kabakov anyway? We never find the answers, since the artist perpetually hides behind his characters.

'How can we fall asleep like we did in childhood, in a way that brings us rest and tranquillity?' With this question, we are immediately led into the utopian imagination that everyone carries around in their private thoughts. But is the sleep of childhood so perfectly tranquil? Childhood itself is a utopian project, a construction built on a longing for the lost Eden of childhood to which we can never return, not least because it is a utopia that only ever existed in the idealisations of memory.

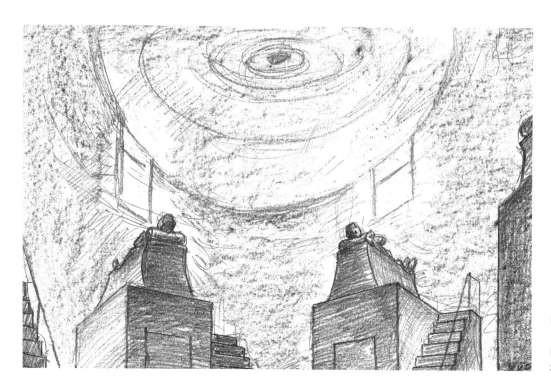

Ilya and Emilia Kabakov
The House of Dreams 2005
Drawing for installation at the
Serpentine Gallery, London

The Kabakovs' proposed 'solutions' – the models, drawings, instructions and installations that serve as the protocols of their projects – are all embodiments of an imaginative response to the ordinary dilemmas of life. Often the artists' instructions wander through an imperial grandiosity, with absurd pomp and circumstance, telling us how to build ridiculously elaborate contraptions to respond to these simple quandaries of daily life. In the drawings for *The House of Dreams* we are asked to imagine ourselves resting on a bed atop a three-metre high plinth, shaped like Napoleon's tomb. We imagine ascending a staircase to this elevated bed, under a light-filled cupola. But inside the plinth (which we enter through a door at ground level) is a dimly lit, windowless room where there is another bed, surrounded by gossamer curtains on which a shadow play of 'magical and intriguing heroes from fairytales' dances. Then in a third form of 'therapeutic' sleep, in the two adjacent galleries the Kabakovs construct rows of beds, curtained on three sides as in a hospital ward. They tip the beds up so that the patient looks out through windows into the natural beauty of the surrounding park. These 'treatment rooms' flank the rotunda and we must traverse them en route to the central space.

To be sure, *The House of Dreams* draws on the Kabakovs' formative lives in the drab interiors that lay behind the shallow facade of post-war Soviet pretensions to grandeur. The numbing bureaucracy, the cramped, degrading existence of the communal apartment provided the detailed narratives of nothing from which Ilya's early work derived its specificity. But that is only an instance, a kind of shopping trip into a warehouse of details that the Kabakovs use to explore the larger and more universal subject of the human imagination in its encounter with the reality of lived experience everywhere. It is 'daily life', he noted, 'that brings new ideas'.[13]

The Kabakovs also draw on the history of Russian utopias as source material. Specifically, the architect Konstantin Melnikov's mad schemes for the new collective man in the Stalinist 1930s provided one of the

Kabakovs' jumping off points for *The House of Dreams*. In his *Competition Project for the 'Green City'*, 1929, Melnikov proposed a *Laboratory of Sleep* in which some 4,000 workers would take a restorative sleeping cure, in vast open wards, that would return them to even greater productivity in the Moscow assembly lines of the interwar period. The building shows two long wings with a central rotunda (like the Kabakovs' *The House of Dreams*). The floors sloped and the built-in beds tipped towards the 'healthful' light and nature. Melnikov imagined 'scientific facts' enhancing this collectivised sleep, with instruments to regulate temperature, humidity, air pressure, even disseminating perfumes and restful sounds such as the murmur of waves, the cooing of nightingales, the rustle of leaves. His technicians would 'rationalize the sun', as in Peter Weir's 1998 film *The Truman Show*, and if all this should fail, the mechanised beds would begin to rock gently. Melnikov aspired to rehabilitate the soviet worker with the combined influences of architecture and science.[14]

Melnikov's building was inspired by his work on *Lenin's Tomb*, a porphyry bunker built in 1930 that rests against the Kremlin wall. The Kabakovs' vision is also haunted by the proximity of sleep and death. In *The House of Dreams* you sleep on top of a sarcophagus and in your dreams your mind travels, dislocating the fixity of your place in time and space. Their *Where Is Our Place?*, an installation for the *50th Venice Biennale* in 2003, also explores this state of dreaming in which one shrinks or expands in the *Alice in Wonderland* ambiguities of one's evolving relationship to the past, the present and the future. Like *Lenin's Tomb*, *The House of Dreams* is a utopian proposal — as are all of the Kabakovs' works — and yet they are refugees from the failure of the most fully realised utopian proposition of the modern age. In Soviet society, Ilya told me, you always had a utopian ideal and a terrible life. You had no sense that you had the right to live your own life, as you do in the United States, and so if you survived you were happy: 'Thank you, thank you' — you were always looking for permission outside yourself.[15]

Creativity is central in the Kabakovs' utopia and they point to the high-level games of fantasy explored in the small, privileged circle of theoretical physicists around Lev Landau in Moscow during the 1940s as confirmation of the centrality of imagination even in science. They also allude to the utopia of the great Soviet scientist VI Vernadsky, who saw the envelope around the earth as evolving from a biosphere towards a more open field of creativity, founded in the power of the human mind. He called this the 'noosphere', in which reason would prevail over the negative potential of technological innovation.

In *The Palace of Projects*, the Kabakovs built 'a unique museum of dreams, a museum of hypotheses and projects', and insisted that 'even if they are unrealizable … the visitor to such a "Palace" will encounter stimulus for his own fantasies, much will prompt him toward the resolution of his own tasks, will awaken his imagination and, the main thing, will provide the impulse for his own creative activity'.[16] In *The House of Dreams*, the Kabakovs ask us to explore different protocols of sleep in order to dream about reality. Each dream, each circumstance of dreaming, becomes an interface for the 'endless and unstructured collection of images, texts, and other data records',[17] and offers a panoply of equivalent structures to constitute and reconstitute our reality. Kandinsky's painting was a spiritual utopia; the computer is a utopia of mathematical predictability; the Kabakovs' utopia is the unfettered realm of the creative imagination.

I would like to thank my colleagues Kevin Hamilton, a new media artist, and Roy Campbell in the Department of Computer Science at the University of Illinois, for thought-provoking conversations about the Kabakovs' work in a course we taught together in the summer of 2005. I would also like to thank our Chancellor, Richard Herman, who has made this kind of trans-domain creativity a priority in the new profile of this remarkable University.

1

The installations and writings that were first made in Moscow are entirely authored by Ilya Kabakov, though some of these, like *The Boat of My Life* and *Ten Characters* were not actually constructed until after his arrival in New York. However, in 1989 Ilya began working with his wife, Emilia. At first she mostly translated from his Russian, undertook minor rewriting and editing, and discussed the realisation of the projects with him. But very quickly her role in conceptualising the projects grew into a full partnership and most of the texts dating from 1989 onwards are a complex collaborative mix of both artists' input, although all drawings are by Ilya and in general he wrote down all the texts to maintain stylistic consistency, even when Emilia was virtually dictating parts of them. Most of the time Ilya signed the writings on behalf of them both. In the book of theory *On The Total Installation* (Stuttgart: Cantz, 1995), for example, whole chapters are written almost entirely by Emilia, even though Ilya is credited on the book as the author. In *The Palace of Projects*, several of the projects are entirely Emilia's, as for example, 'A Low Flight Above The Earth', which derives from a recurring dream of hers. In the installation about the life of Charles Rosenthal, the conception of the character Ilya Kabakov is mostly authored by Emilia and the idea that the Spivaks character nostalgia for Soviet life lends a pink cast to his work comes from her. In general, the more mystical ideas tend to be Emilia's.

2

Lev Manovich, 'Database as a Symbolic Form', http://manovich.net/, previously published as 'The Database Logic' in Lev Manovich, *The Language of New Media* (Cambridge, Mass: MIT Press, 2001), p 223

3

Ilya Kabakov, 'The Palace of Projects', in Ilya and Emilia Kabakov, *The Palace of Projects* (Essen: Kokerei Zollverein, 2001), np

4

Ilya Kabakov, 'Foreword To The Installation', in Ilya and Emilia Kabakov, *The Palace of Projects, op. cit.*

5

Originally dating from *c*1977, this work is now permanently installed in the National Museum of Contemporary Art in Oslo.

6

Ilya Kabakov, *The Man Who Never Threw Anything Away (The Garbage Man)*, from Ilya Kabakov, *Ten Characters* (London: Institute of Contemporary Art, 1989), p 42; reprinted in Boris Groys, David Ross and Iwona Blazwick, *Ilya Kabakov* (London: Phaidon Press, 1998), p 98

7

Ibid., pp 98–99

8

Ibid., p 100

9

Ilya Kabakov, *On The Total Installation, op. cit.*

10

Ilya Kabakov, *Ten Characters*, text accompanying an installation at Ronald Feldman Fine Arts, New York, 1988; cited in David Ross, ed., *Between Spring and Summer: Soviet Conceptual Art in the Era of Late Communism* (Boston: Institute of Contemporary Art; Tacoma, Washington: Tacoma Art Museum; Cambridge, Mass and London: MIT Press, 1990), pp 25–27

11

Jonathan Fineberg, ed., *Ilya Kabakov: The Boat of My Life* (Champaign, Illinois: Krannert Art Museum, 1998), p 148; this text is a complete transcription (with some typographical corrections, and translations by Jonathan Fineberg of a number of missing passages that were included in the German edition of the book) of the English text in: Ilya Kabakov, *The Boat of My Life*, trans. Cynthia Martin (New York: limited edition produced by the artist, 1993).

12

Ilya Kabakov, '3.1 "A Room Taking Off In Flight"', in Kabakov, *The Palace of Projects, op. cit.*

13

Ilya Kabakov, in Katrina F C Cary, 'Ilya Kabakov: Profile of a Soviet Unofficial Artist', *Art and Auction* (February 1987), pp 86–87; cited in Robert Storr, *Dislocations*, (New York: Museum of Modern Art, 1991), p 22

14

See S Frederick Starr, *Melnikov: Solo Architect in a Mass Society* (Princeton, NJ: Princeton University Press, 1978), 176 ff. The heir of Konstantin Melnikov refused permission to reproduce these drawings on this occasion but they appear in Starr's publication.

15

Ilya Kabakov, conversation with the author, Mattituck, New York, 3 April 2005

16

Ilya Kabakov, 'Foreword To The Installation', in Kabakov, *The Palace of Projects, op. cit.*

17

Manovich, *op. cit.*, p 219

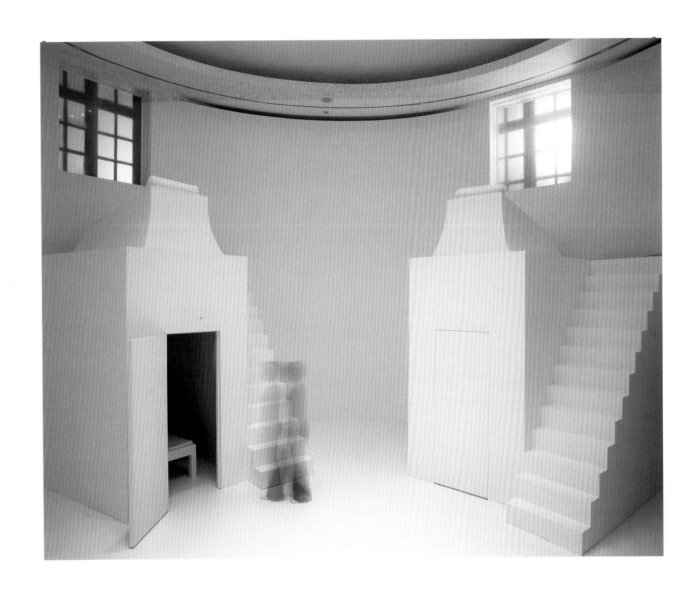

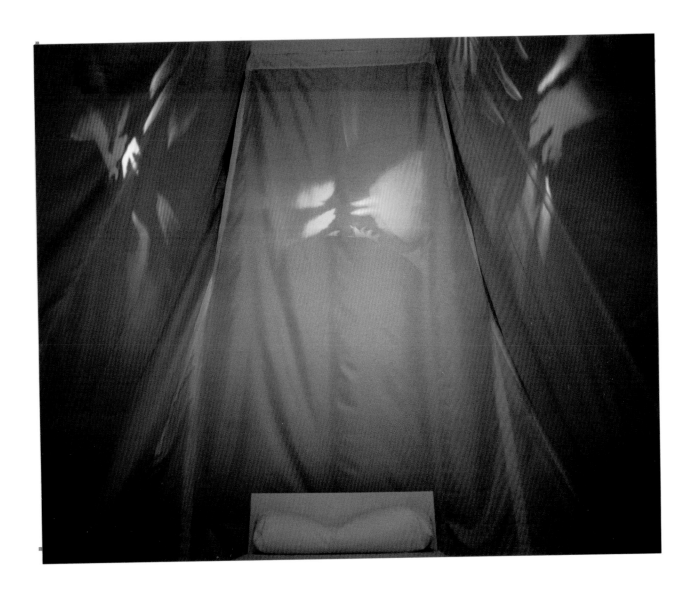

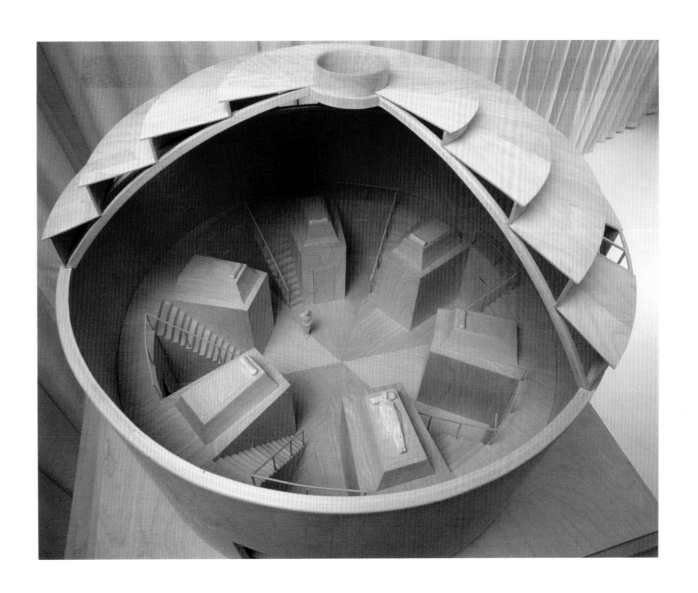

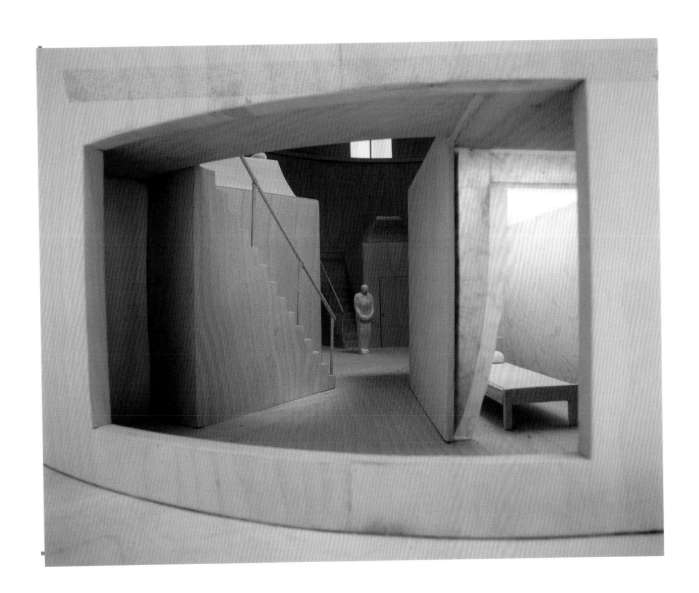

Biography

Ilya Kabakov was born in Dnepropetrovsk, Soviet Union, in 1933. He studied at the VA Surikov Art Academy in Moscow, and began his career as a children's book illustrator during the 1950s, later becoming one of a group of Conceptual artists in Moscow who worked outside the official Soviet art system. In 1985 he received his first solo exhibition at Dina Vierny Gallery, Paris, and he moved to the West two years later, taking up a six-month residency at Kunstverein Graz, Austria. His work has been presented in public institutions in London on many occasions, first in the group exhibition *Unofficial Art from the Soviet Union* in 1977, and again in *Ilya Kabakov: The Untalented Artist and Other Characters* in 1989, both at the Institute of Contemporary Art. The latter was shown concurrently with *10 Albums: 10 Characters* at Riverside Studios in 1989, and more recently his work was included in *Open Systems: New Art in the 1960s and 1970s* at Tate Modern, 2005.

Emilia Kabakov (née Kanevsky) was born in Dnepropetrovsk, Soviet Union, in 1945 and attended the Music College in Irkutsk, in addition to studying Spanish language and literature at Moscow University. She emigrated to Israel in 1973, and moved to New York in 1975, where she worked as a curator and art dealer. She began working with Ilya Kabakov in 1989, and they married in 1992. As well as publishing books that archive the complete history of their work, the pair has collaborated on large-scale projects and ambitious installations, and their work has been shown in major international exhibitions. In 1993 they represented Russia at the *45th Venice Biennale* with their installation *The Red Pavilion*, and their work *The Palace of Projects*, commissioned by Artangel, was presented at the Roundhouse in London in 1998. Their solo exhibition *Incident at the Museum and Other Installations* at the State Hermitage Museum in St Petersburg, 2004, marked Ilya's first visit to Russia since leaving the

country in 1987 and was also the debut exhibition by living Russian artists to be held there.

Major group shows have included *Magiciens de la Terre* at Musée national d'art moderne, Centre Pompidou, Paris, in 1989; *Dislocations* at the Museum of Modern Art, New York, and the *Carnegie International* in Pittsburgh, both in 1991; *Documenta IX* in Kassel, Germany, in 1992; and *Russia!*, a large-scale historic exhibition at the Solomon R Guggenheim Museum in New York in 2005.

The Kabakovs have also completed many important public commissions throughout Europe and have received a number of honours and awards, including the Oskar Kokoschka Preis, Vienna, in 2002 and Chevalier des Arts et des Lettres, Paris, in 1995. They live and work in Mattituck, New York.

David and Janice Blackburn
Anthony and Gisela Bloom
John and Jean Botts
Marcus Boyle
Vanessa Branson
James and Felicia Brocklebank
Mrs Conchita Broomfield
Benjamin Brown
Mr and Mrs Charles Brown
Ossi and Paul Burger
John and Susan Burns
Mr and Mrs Philip Byrne
Jonathan and Vanessa Cameron
Jonathon P Carroll
Andrew Cecil
Monkey Chambers
Azia Chatila
Mr Giuseppe and the late
 Mrs Alexandra Ciardi
Dr and Mrs David Cohen
Sadie Coles
Louise-Anne Comeau
Carole and Neville Conrad
Sulina and Matthew Conrad
Alexander Corcoran
Pilar Corrias and Adam Prideaux
Gul Coskun
Loraine da Costa
Mr and Mrs Cuniberti
Joan Curci
Linda and Ronald F Daitz
Helen and Colin David
Paul Davies
Ellynne Dec and Andrea Prat
Neil Duckworth
Denise Dumas
Adrienne Dumas
Lance Entwistle
Mike Fairbrass
Mr and Mrs Mark Fenwick
Ruth Finch
Harry and Ruth Fitzgibbons

David and Jane Fletcher
Bruce and Janet Flohr
Robert Forrest
Eric and Louise Franck
Honor Fraser
James Freedman and Anna Kissin
Albert and Lyn Fuss
Lady Deedam Gaborit
Tatiana Gertik
Hugh Gibson
David Gill
Glovers Solicitors
Mr and Mrs John Gordon
Dimitri J Goulandris
Francesco Grana and
 Simona Fantinelli
Richard and Linda Grosse
The Bryan Guinness Charitable
 Trust
Philip Gumuchdjian
Sascha Hackel and Marcus Bury
Abel G Halpern and
 Helen Chung-Halpern
Louise Hallett
Mr and Mrs Rupert Hambro
Mr and Mrs Antony Harbour
Susan Harris
Maria and Stratis Hatzistefanis
Mr and Mrs Rick Hayward
Thomas Healy and
 Fred Hochberg
Michael and Sarah Hewett
Mrs Samantha Heyworth
Marianne Holtermann
Mrs Juliette Hopkins
Mrs Martha Hummer-Bradley
Montague Hurst Charitable Trust
Mr Michael and Lady Miranda
 Hutchinson
Iraj and Eva Ispahani
Nicola Jacobs and
 Tony Schlesinger

Mrs Christine Johnston
Susie Jubb
John Kaldor and Naomi Milgrom
Howard and Linda Karshan
Jennifer Kersis
Malcolm King
James and Clare Kirkman
Tim and Dominique Kirkman
Mr and Mrs Charles Kirwan-Taylor
Herbert and Sybil Kretzmer
The Landau Foundation
Britt Lintner
Barbara Lloyd and Judy Collins
Peder Lund
Steve and Fran Magee
Mr Otto Julius Maier and
 Mrs Michèle Claudel-Maier
Claude Mandel and
 Maggie Mechlinski
Mr and Mrs Stephen Mather
Viviane and James Mayor
Alexandra Meyers
Warren and Victoria Miro
Susan and Claus Moehlmann
Jen Moores
Richard Nagy and Caroline Schmidt
Andrei Navrozov
Angela Nikolakopoulou
Marian and Hugh Nineham
Dalit Nuttall
Georgia Oetker
Sandra and Stephan Olajide
Tamiko Onozawa
Mr and Mrs Nicholas Oppenheim
Linda Pace
Desmond Page and
 Asun Gelardin
Maureen Paley
Dominic Palfreyman
Midge and Simon Palley
Kathrine Palmer
William Palmer

Andrew and Jane Partridge
Pescali & Sprovieri Gallery
Julia Peyton-Jones
George and Carolyn Pincus
Ben and Georgie Pincus
Sophie Price
Mathew Prichard
Max Reed
Michael Rich
John and Jill Ritblat
Bruce and Shadi Ritchie
Jacqueline and Nicholas Roe
Victoria, Lady de Rothschild
James Roundell and
 Bona Montagu
Rolf and Maryam Sachs
Nigel and Annette Sacks
Michael and Julia Samuel
Ronnie and Vidal Sassoon
Isabelle Schiavi
Joana and Henrik Schliemann
Glenn Scott Wright
Martin and Elise Smith
Melissa and Robert Soros
Sotheby's
Mr and Mrs Jean-Marc Spitalier
Bina and Philippe von
 Stauffenberg
Simone and Robert Suss
Emma Tennant and Tim Owens
The Thames Wharf Charity
Christian and Sarah von
 Thun-Hohenstein
Britt Tidelius
Suzanne Togna
Emily Tsingou
Ashley and Lisa Unwin
David and Emma Verey
Darren J Walker
Audrey Wallrock
Rajan and Wanda Watumull
Pierre and Ziba de Weck

Daniel and Cecilia Weiner
Lord and Lady John Wellesley
Alannah Weston
Helen Ytuarte White
Robin Wight and
 Anastasia Alexander
Martha and David Winfield
Richard and Astrid Wolman
Mr and Mrs M Wolridge
Chad Wollen and Sian Davies
Nabil N Zaouk
Andrzej and Jill Zarzycki

Summit Group
Vanessa Branson
Aud and Paolo Cuniberti
Colin and Helen David
Frank and Lorna Dunphy
Joscelyn, Jacqueline &
 Gerald Fox
Eric and Louise Franck
Honor Fraser
Richard and Odile Grogan
Jennifer and Matthew Harris
Iraj and Eva Ispahani
George and Angie Loudon
Mr Otto Julius Maier and
 Mrs Michèle Claudel-Maier
Bona Colonna Montagu
Jennifer Moores
Midge and Simon Palley
Oliver Prenn
Britt Tidelius
Helen Ytuarte White

And Patrons, Benefactors and
Summit Group members who
wish to remain anonymous

**International Media Partner
2004–2005**
Fortune

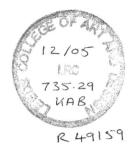

This catalogue is published to accompany

Ilya and Emilia Kabakov: The House of Dreams

at the Serpentine Gallery 19 October 2005 – 8 January 2006

Exhibition curated by Rochelle Steiner, Chief Curator
Organised by Kathryn Rattee, Exhibition Organiser
Julia Peyton-Jones, Director

Catalogue designed by Herman Lelie
Typeset by Stefania Bonelli
Printed by F S Moore
Prepared and published by the Serpentine Gallery, London

Sponsored by

Bloomberg

With additional generous support from

Renaissance Capital

The Henry Moore Foundation

The Serpentine Gallery is funded by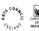

Serpentine Gallery

Kensington Gardens, London W2 3XA

T +44 (0)20 7402 6075 F +44 (0)20 7402 4103 www.serpentinegallery.org

ISBN 1-905190-06-9

Kind assistance from

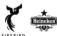